Nombre: ______________________________

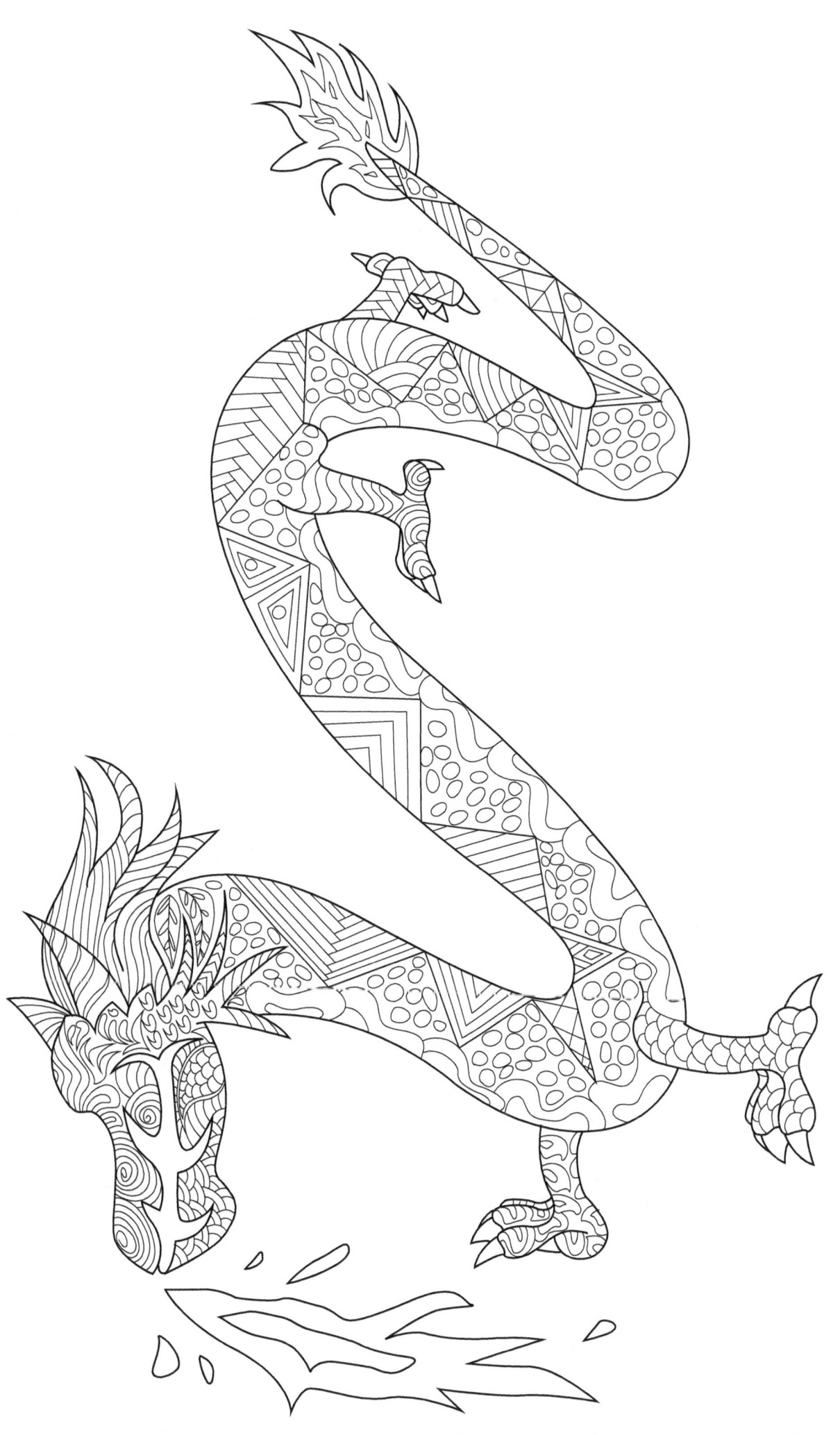

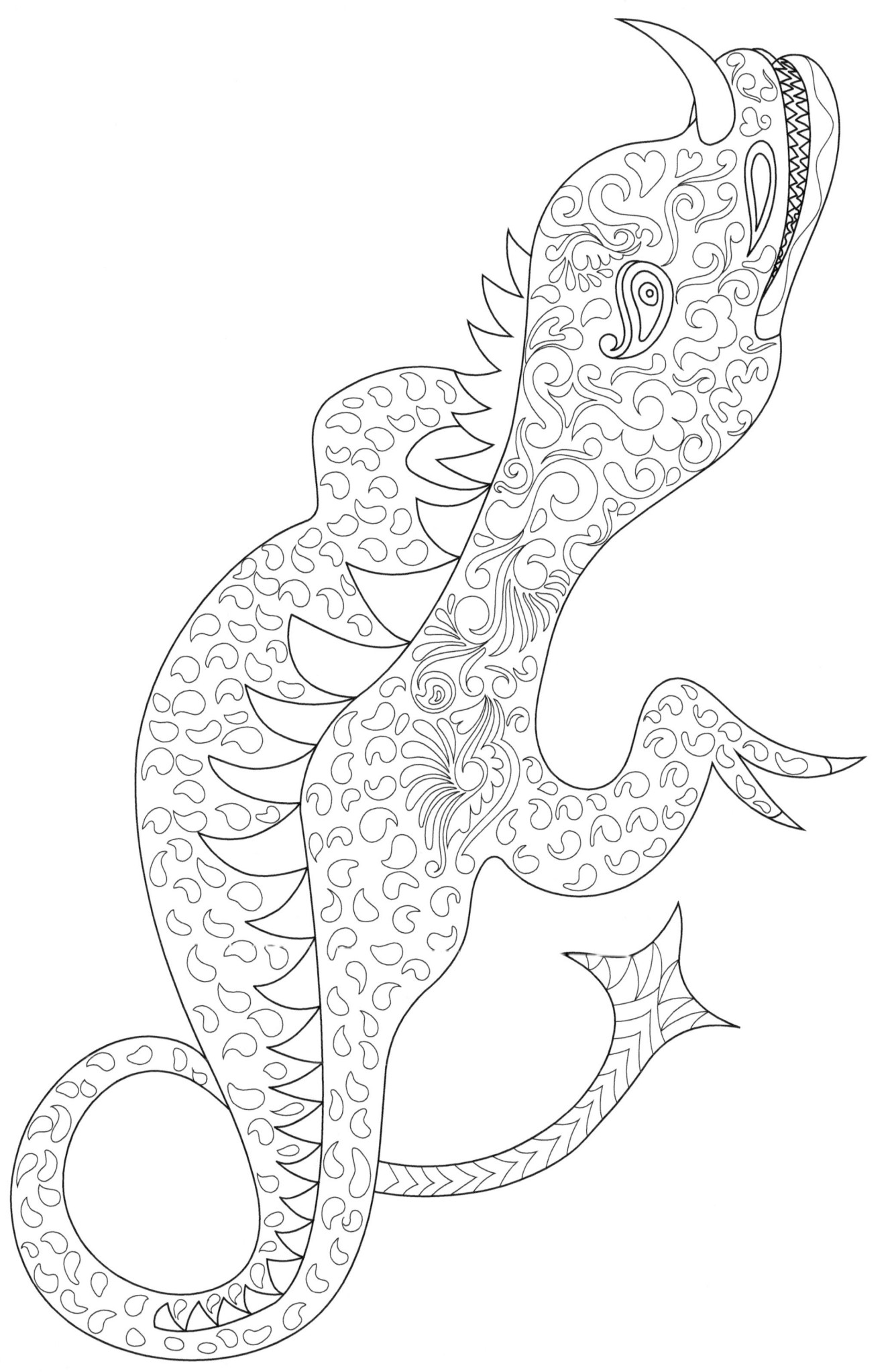

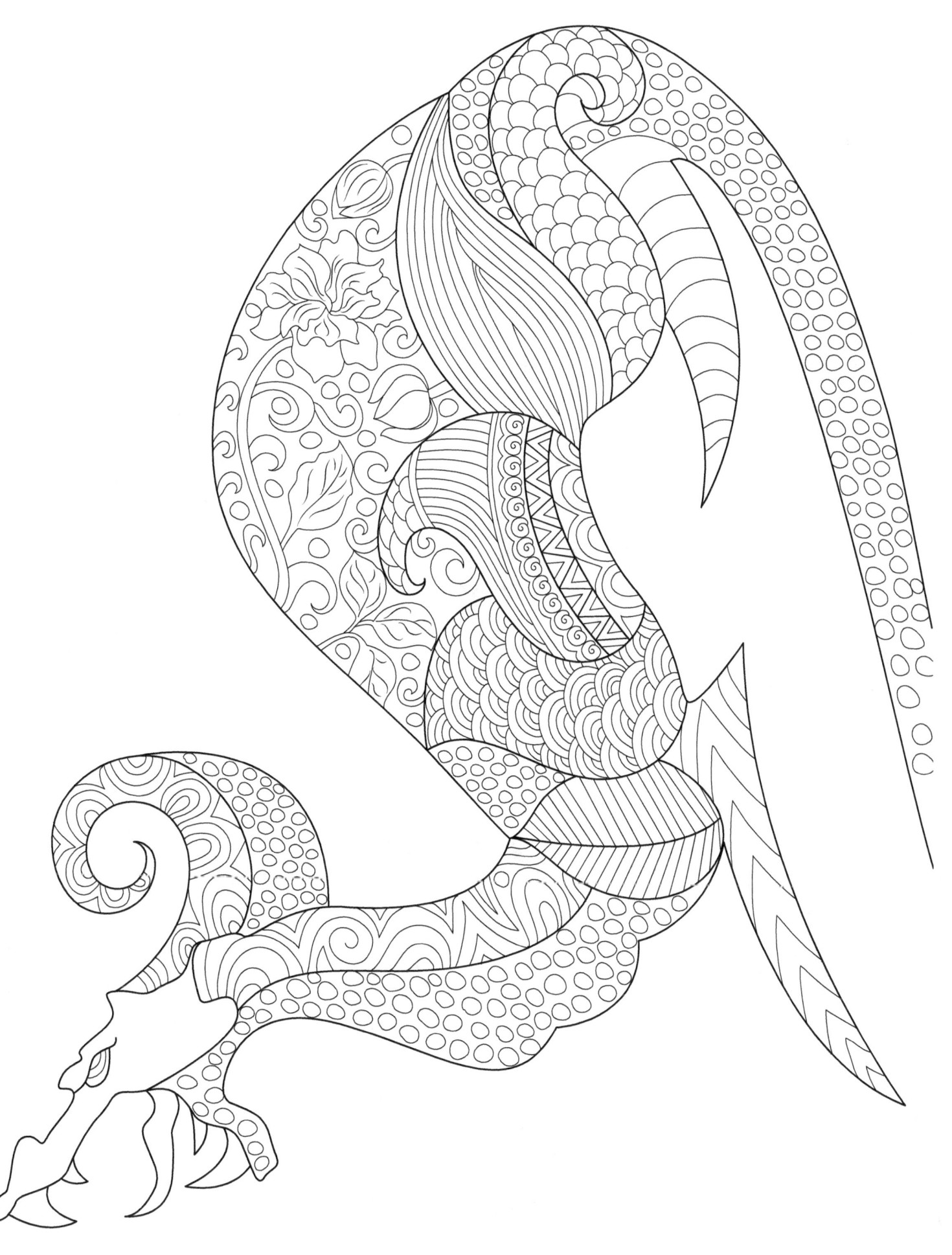

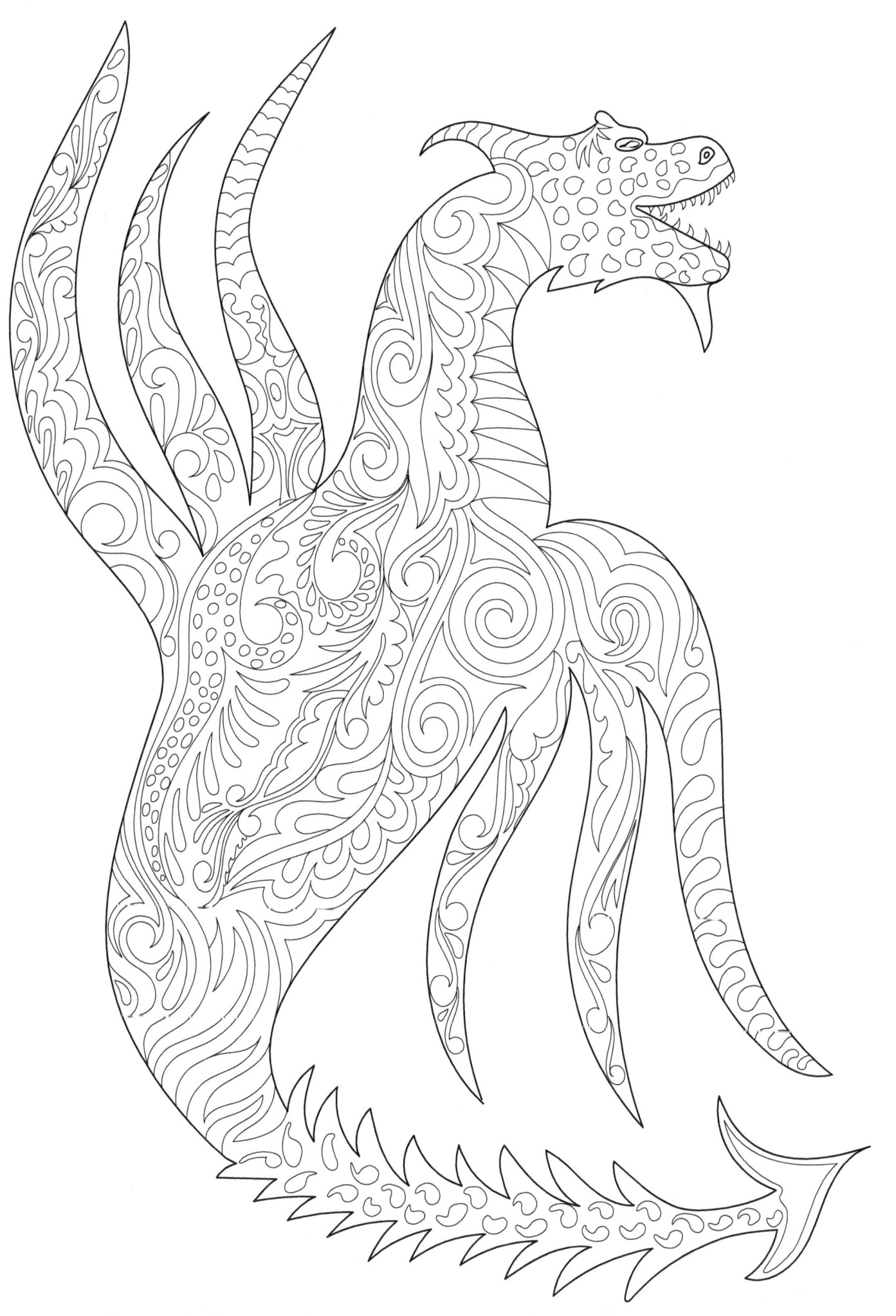

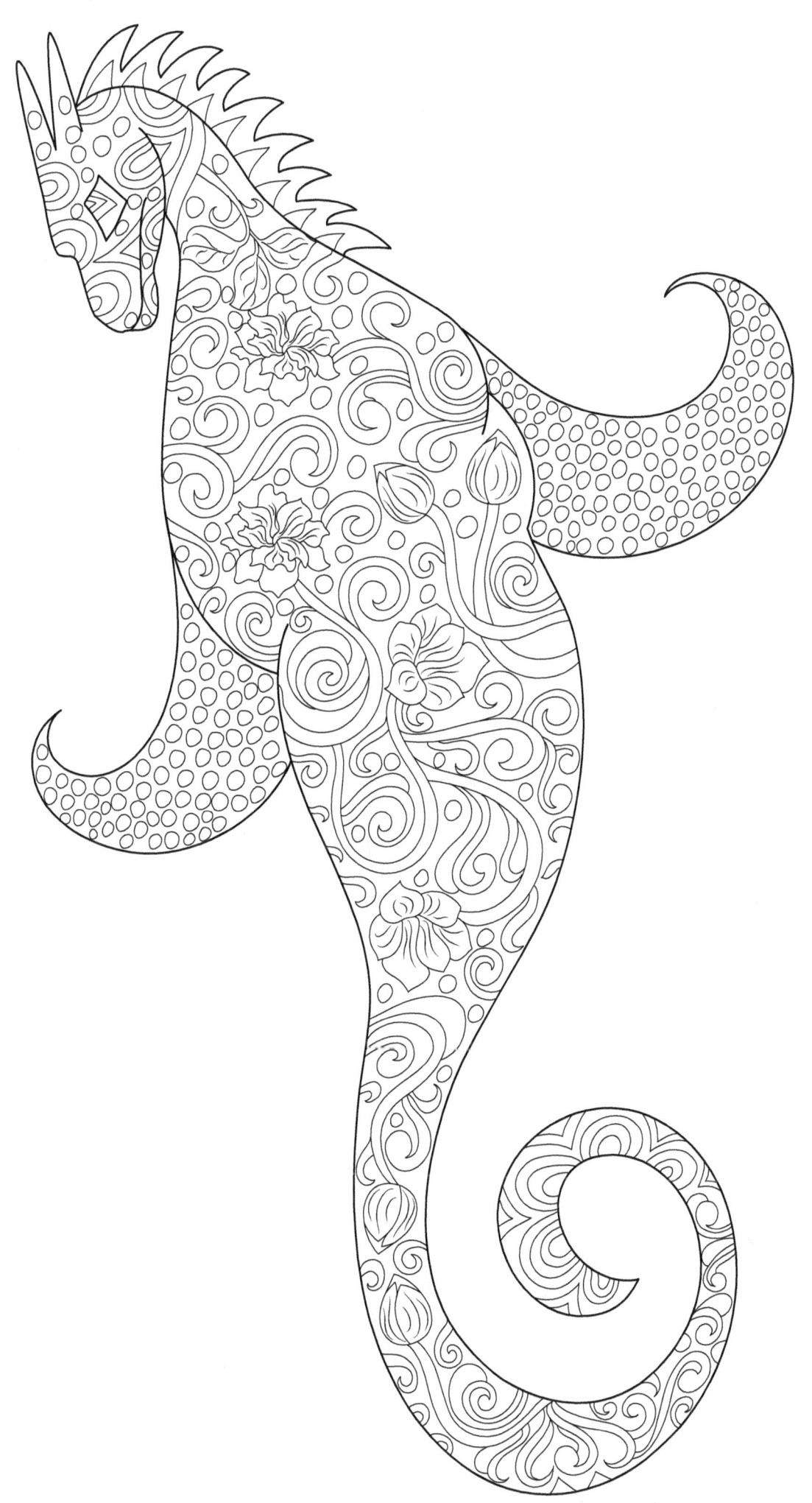

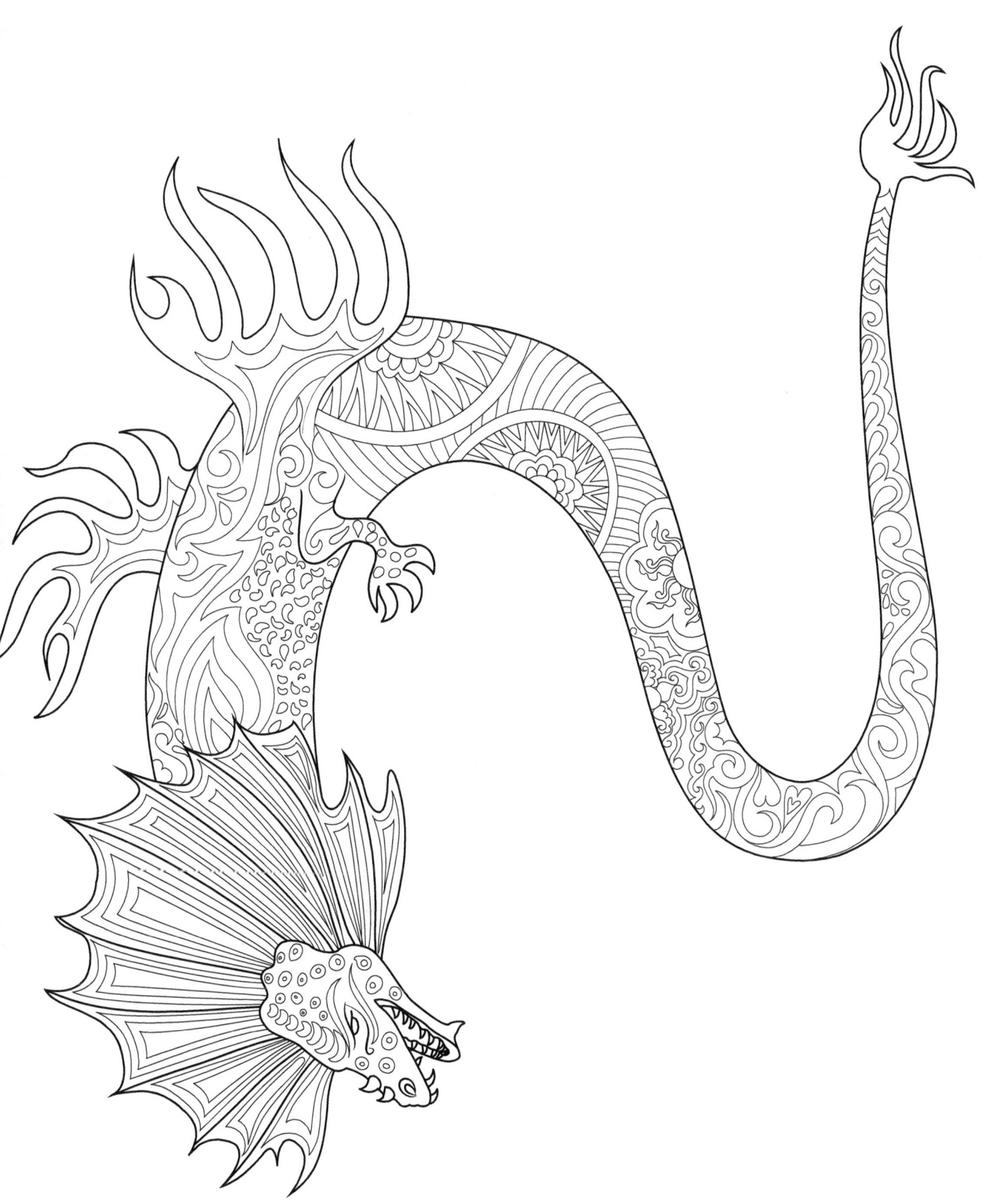

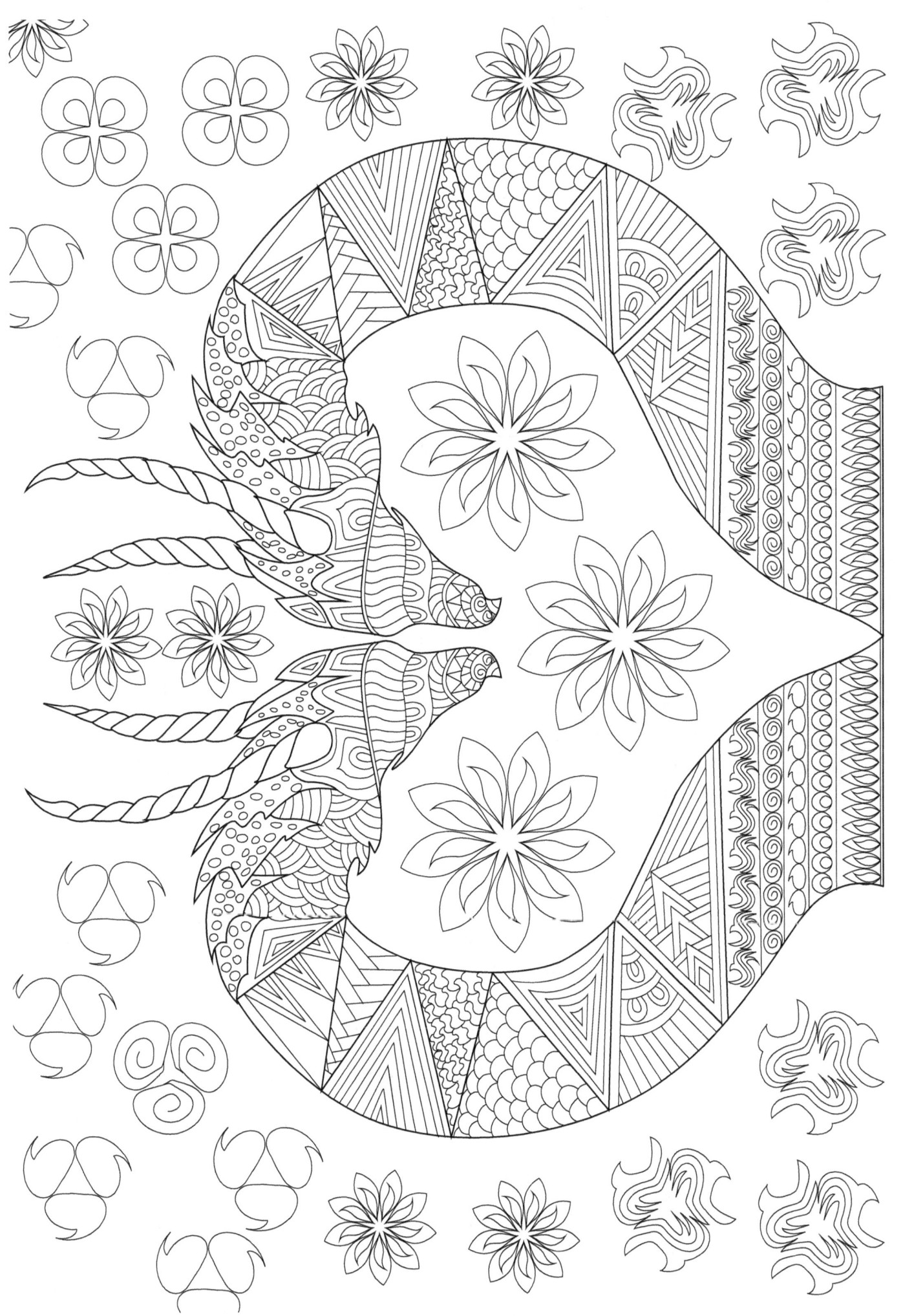

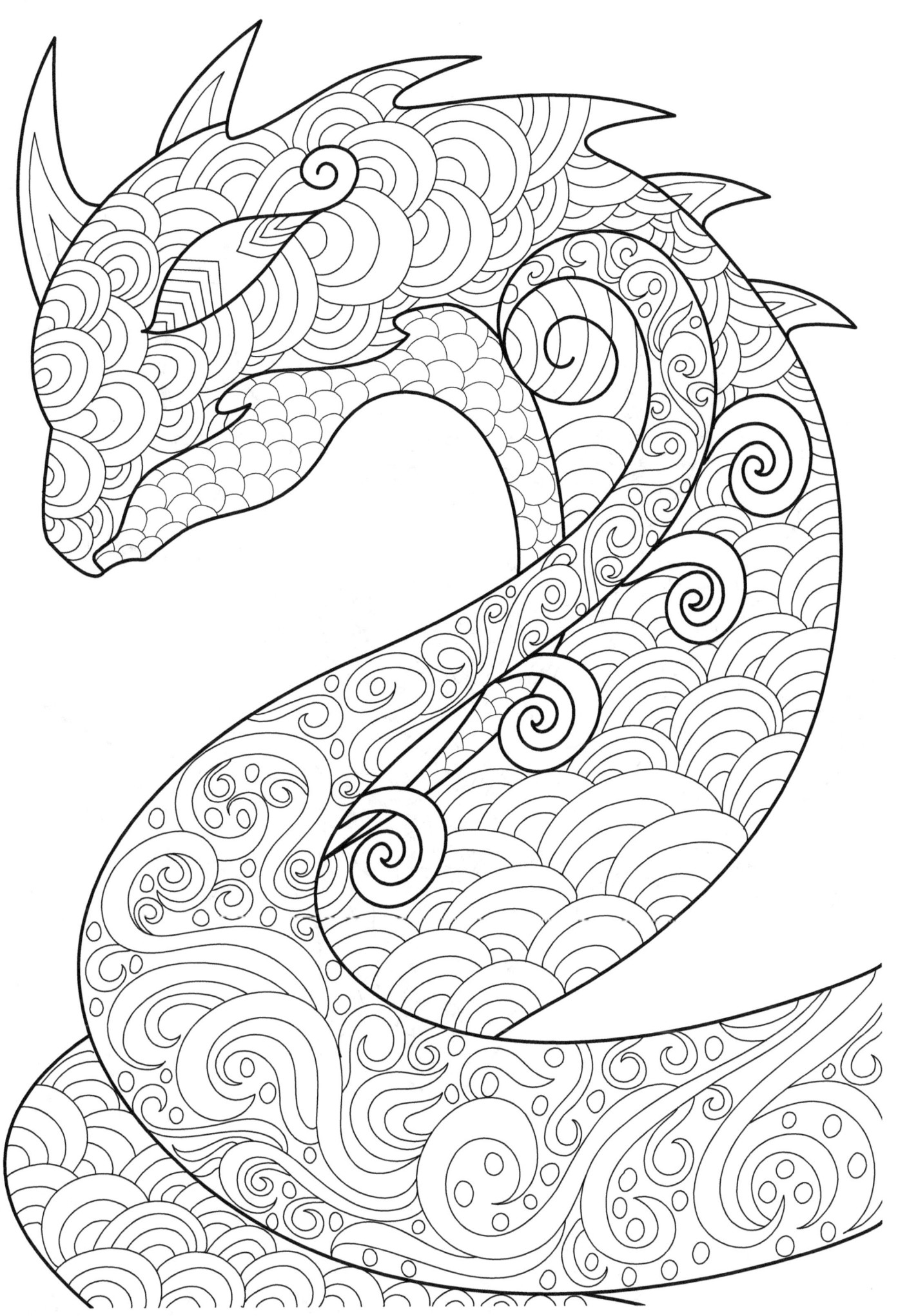

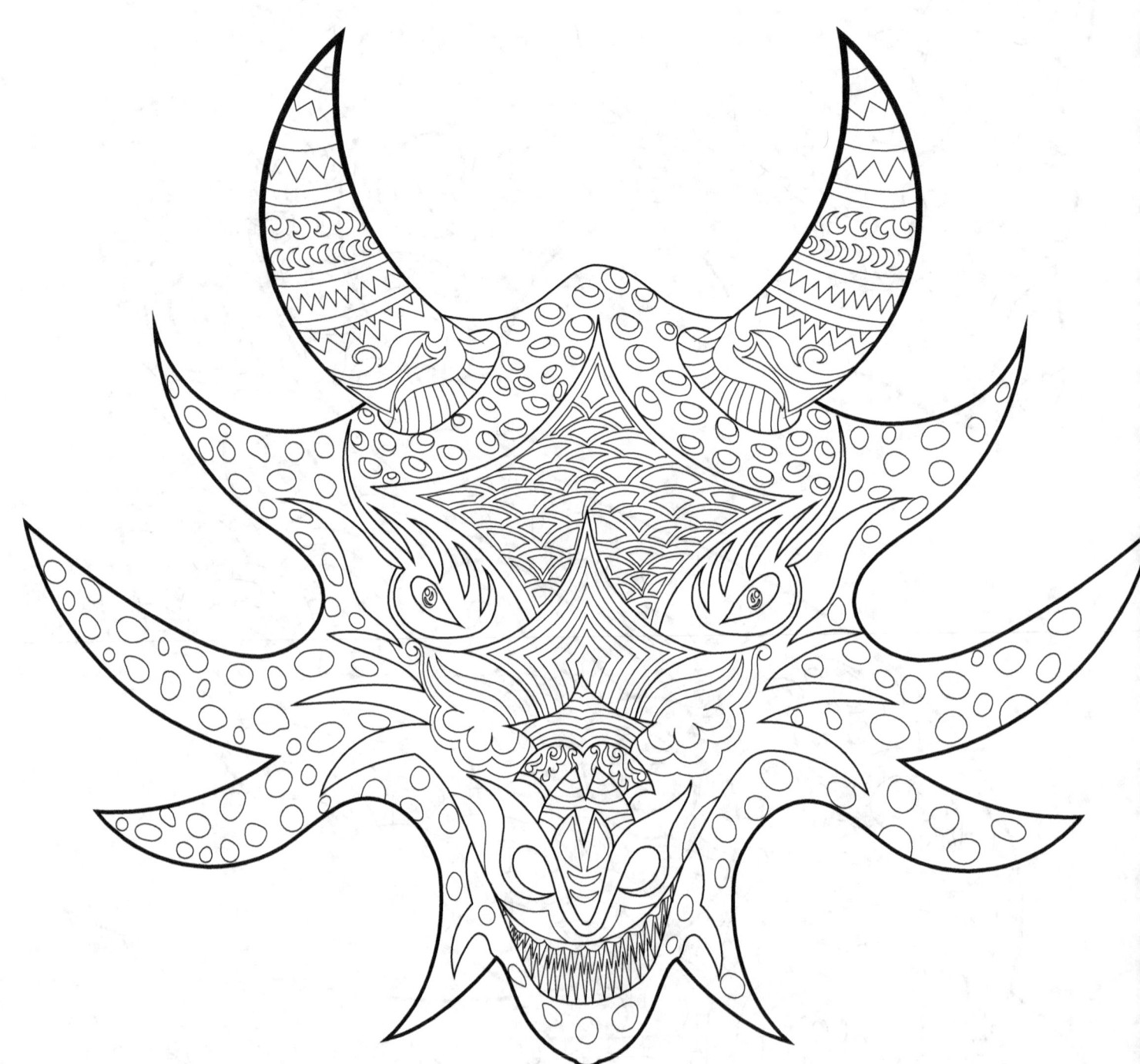

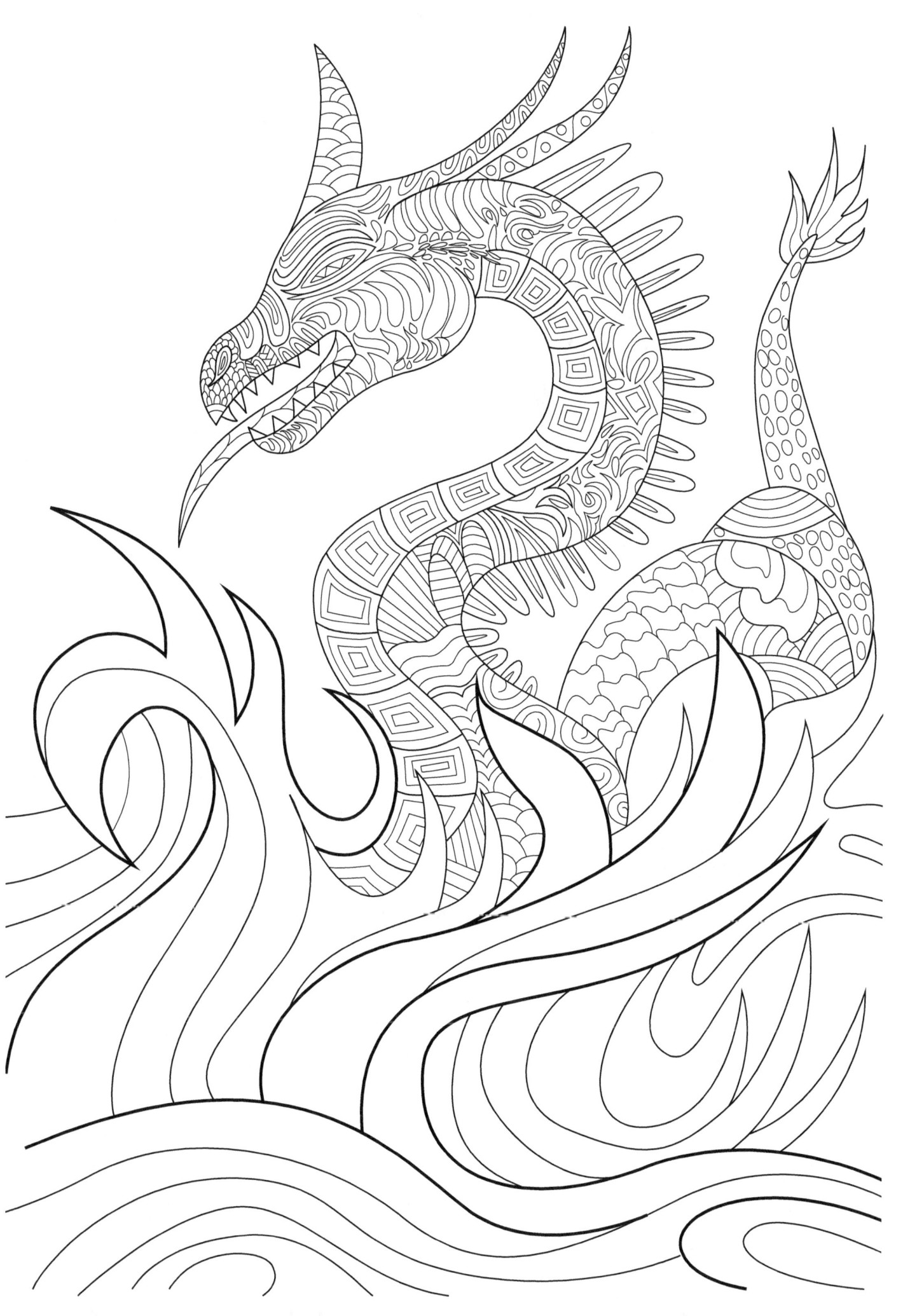

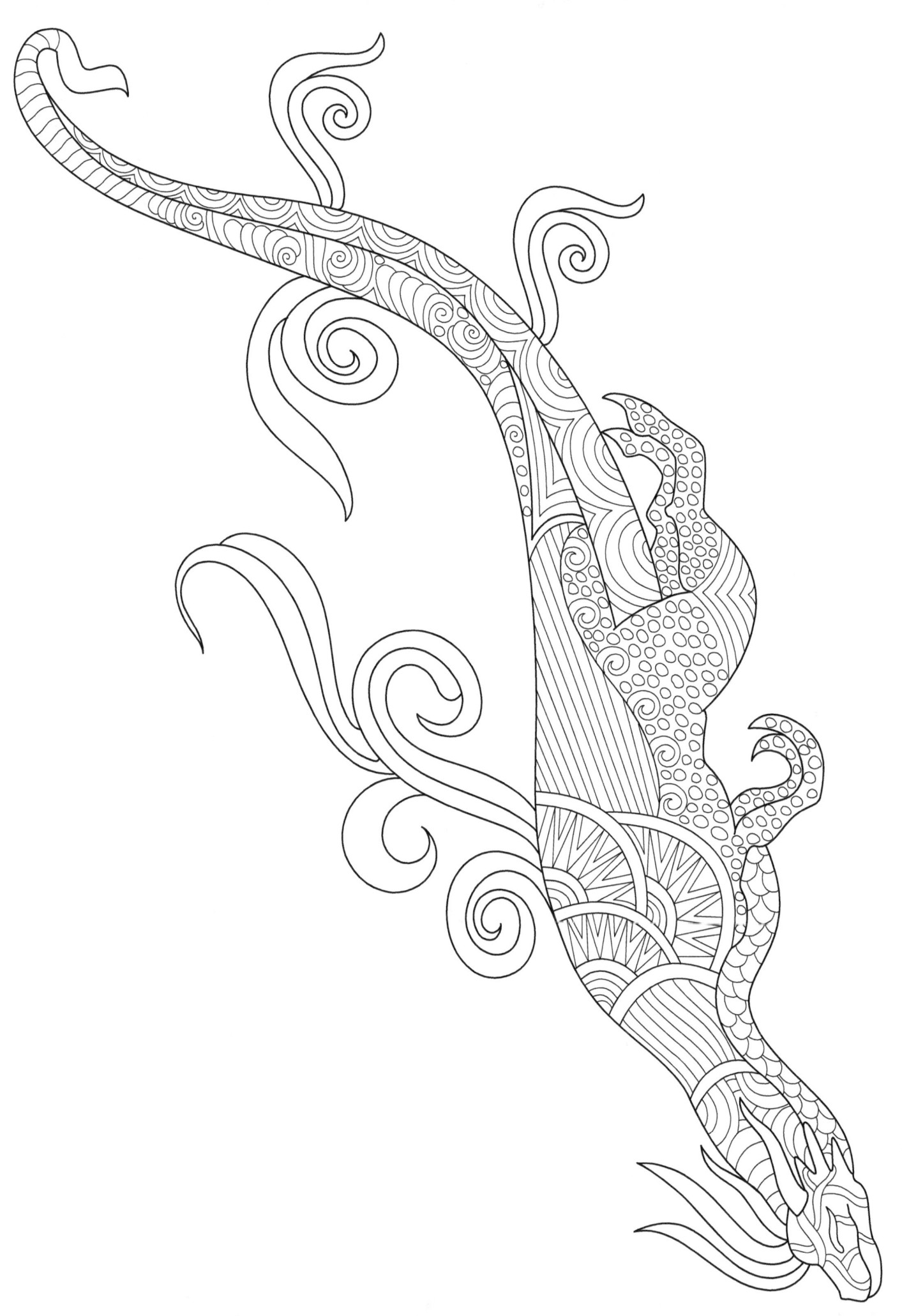

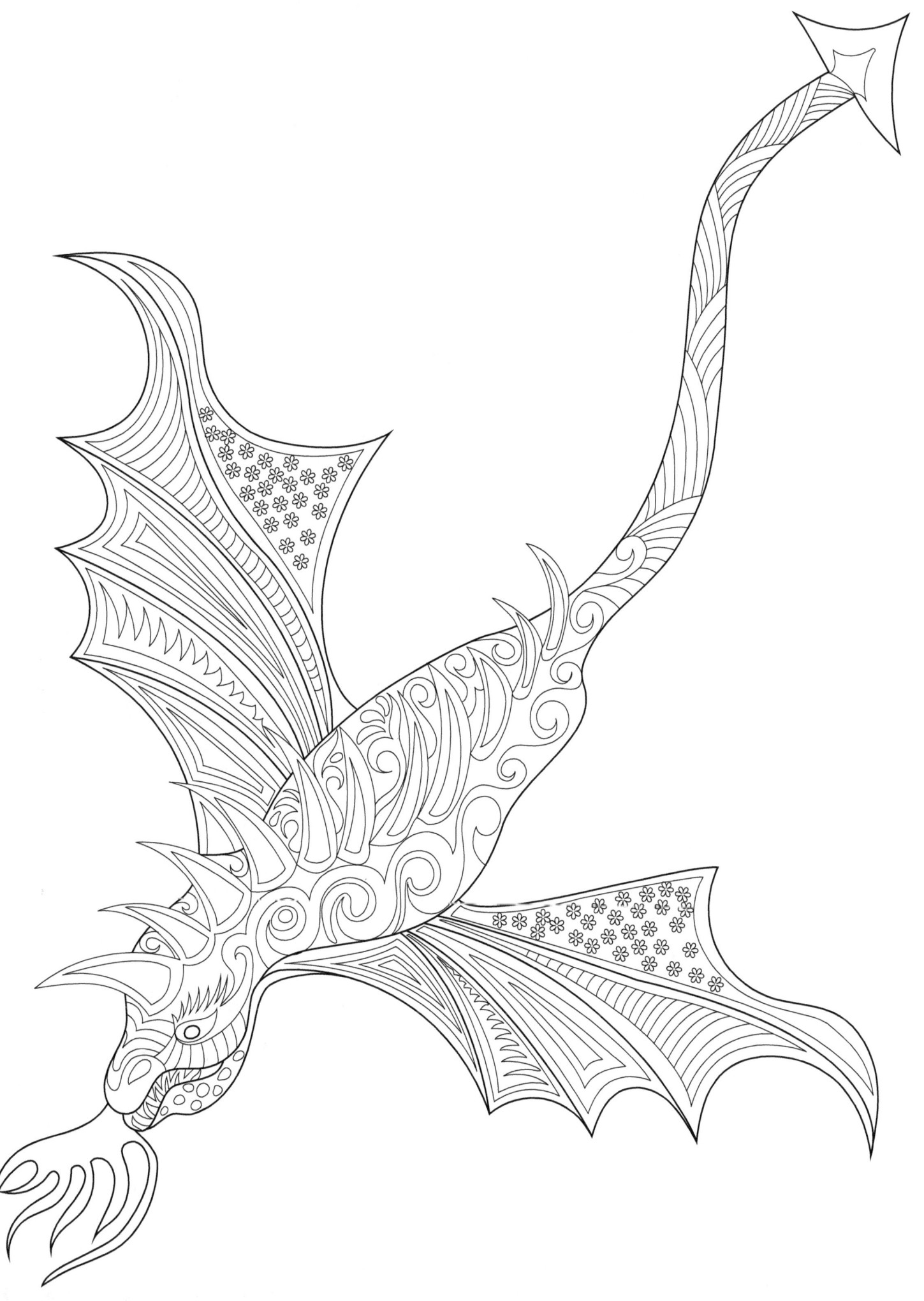

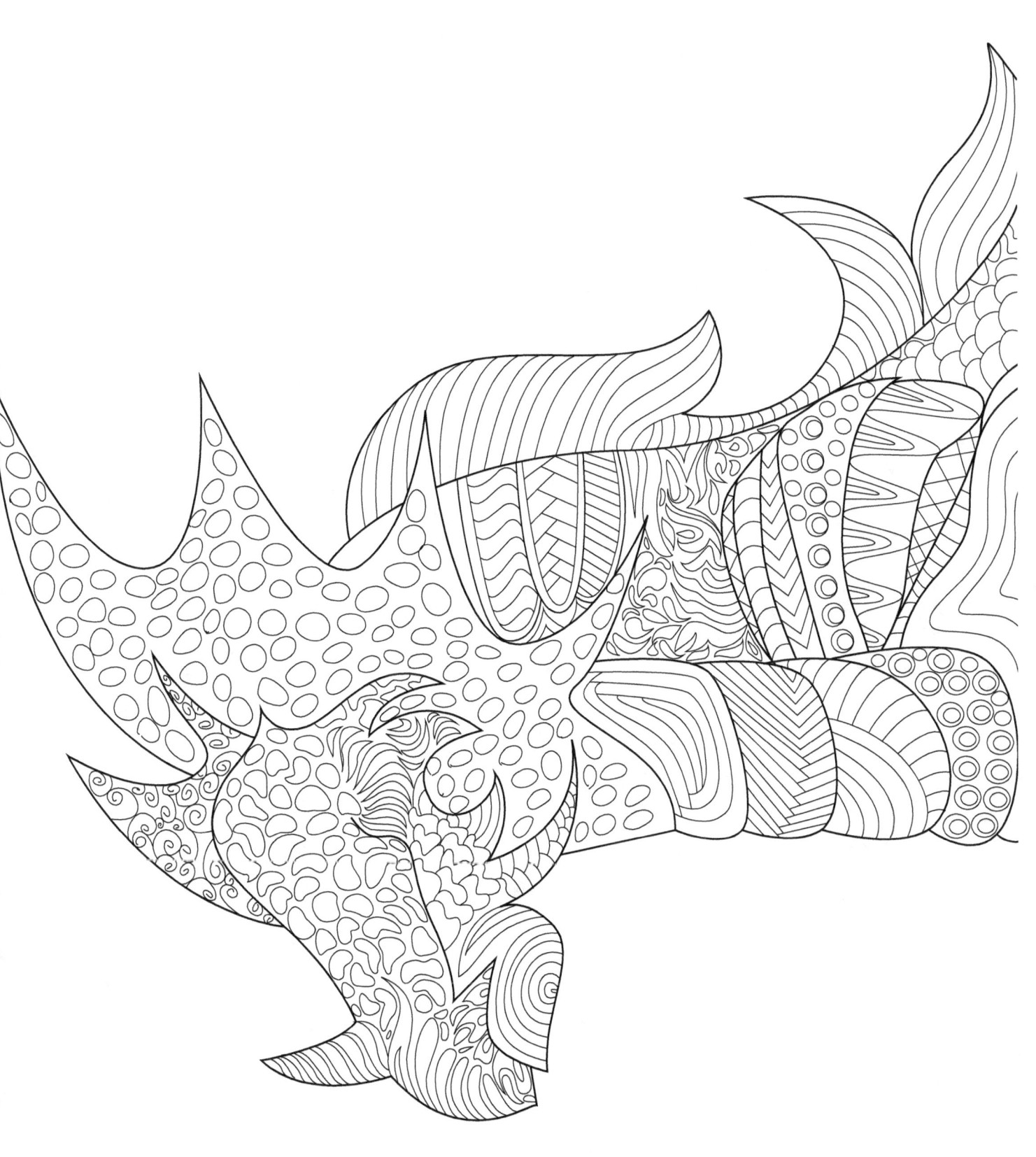

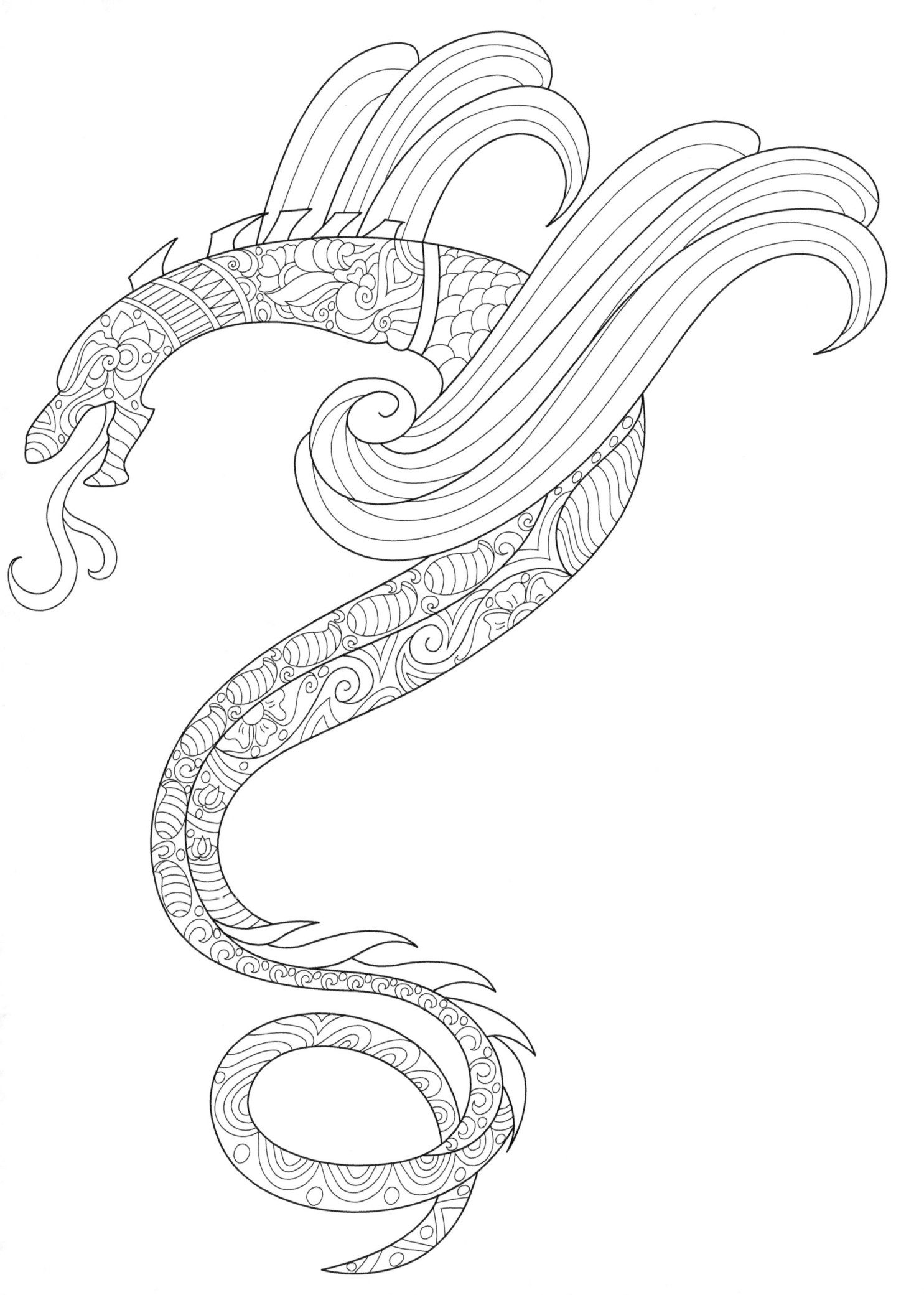

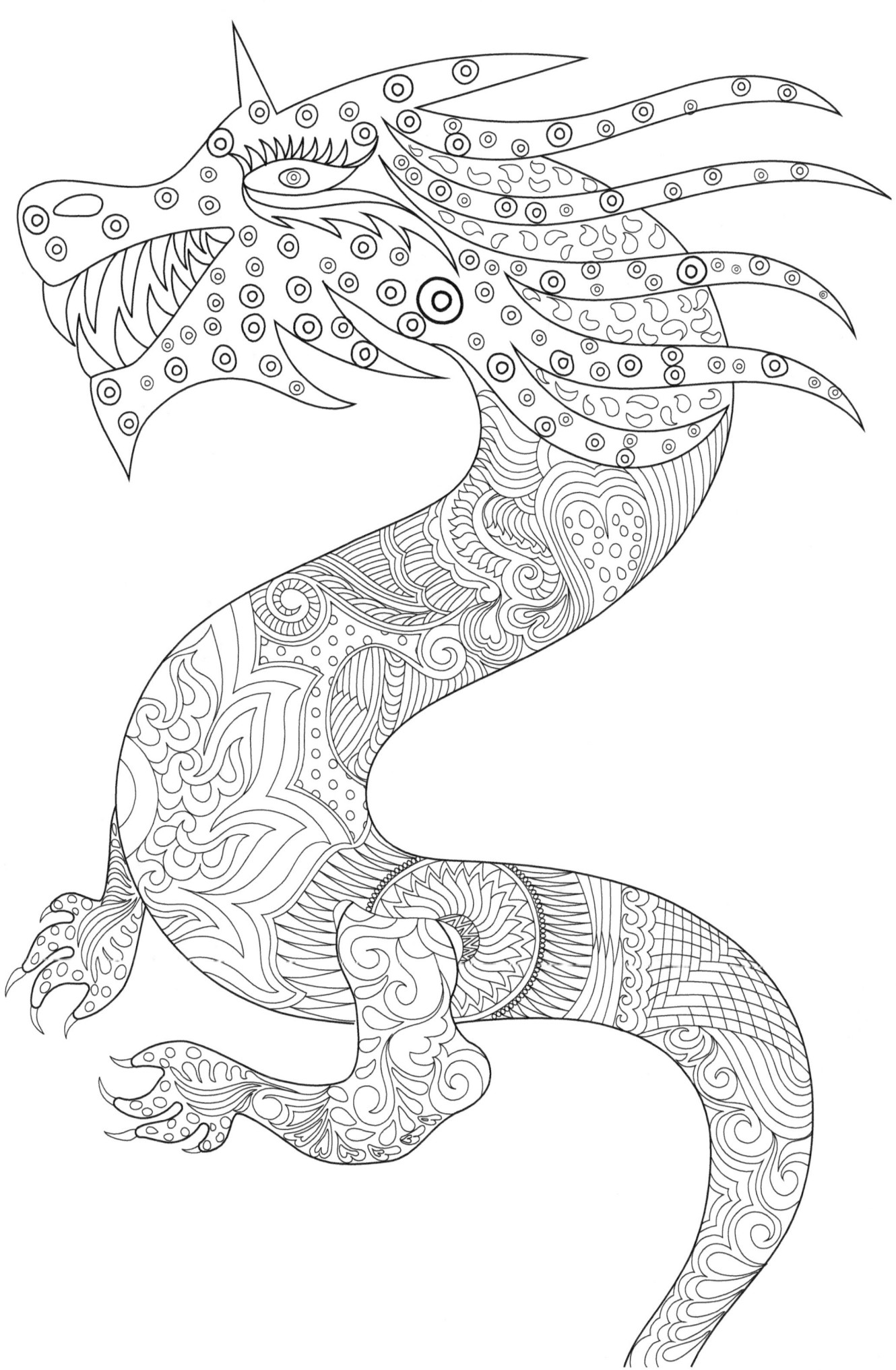

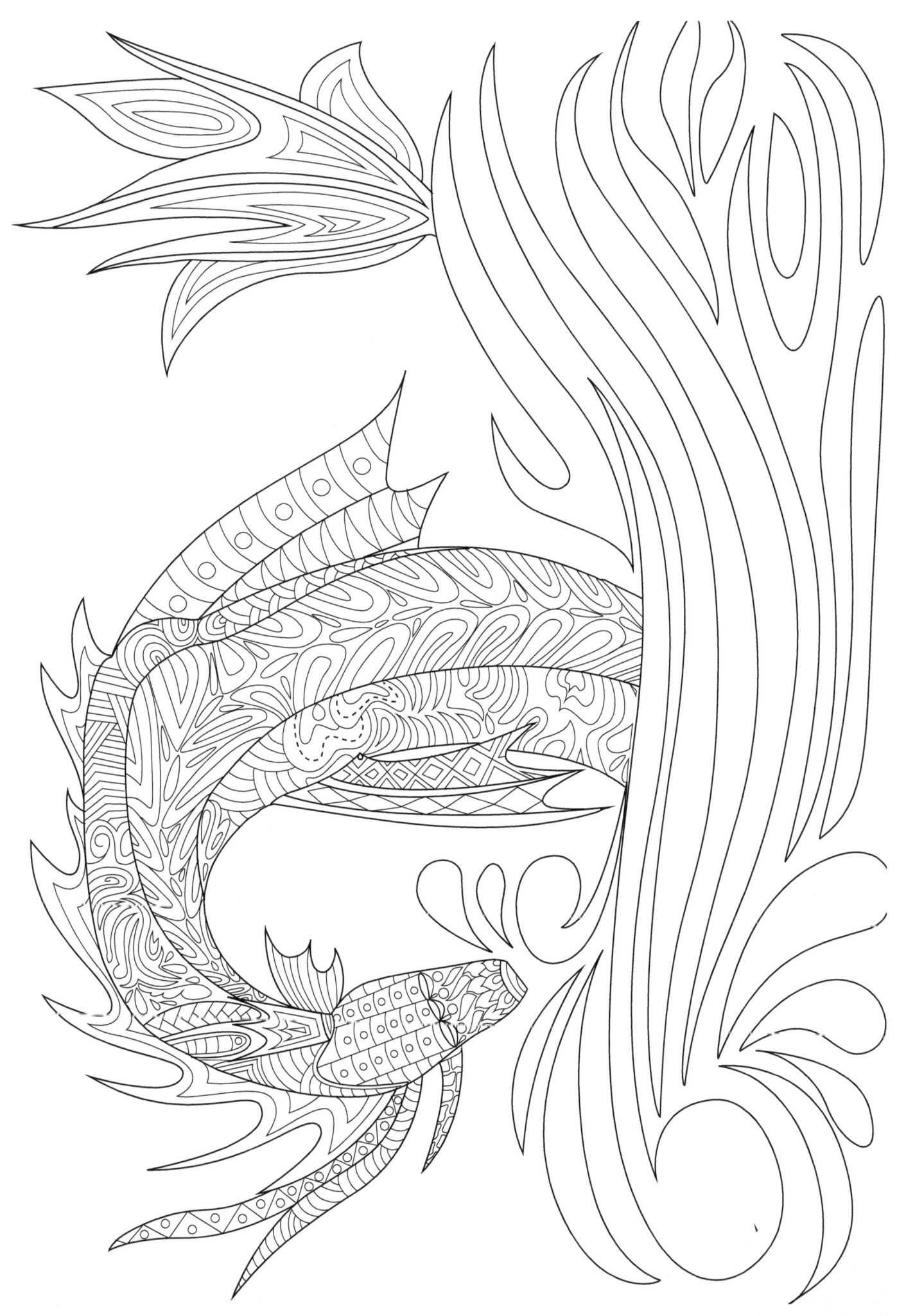

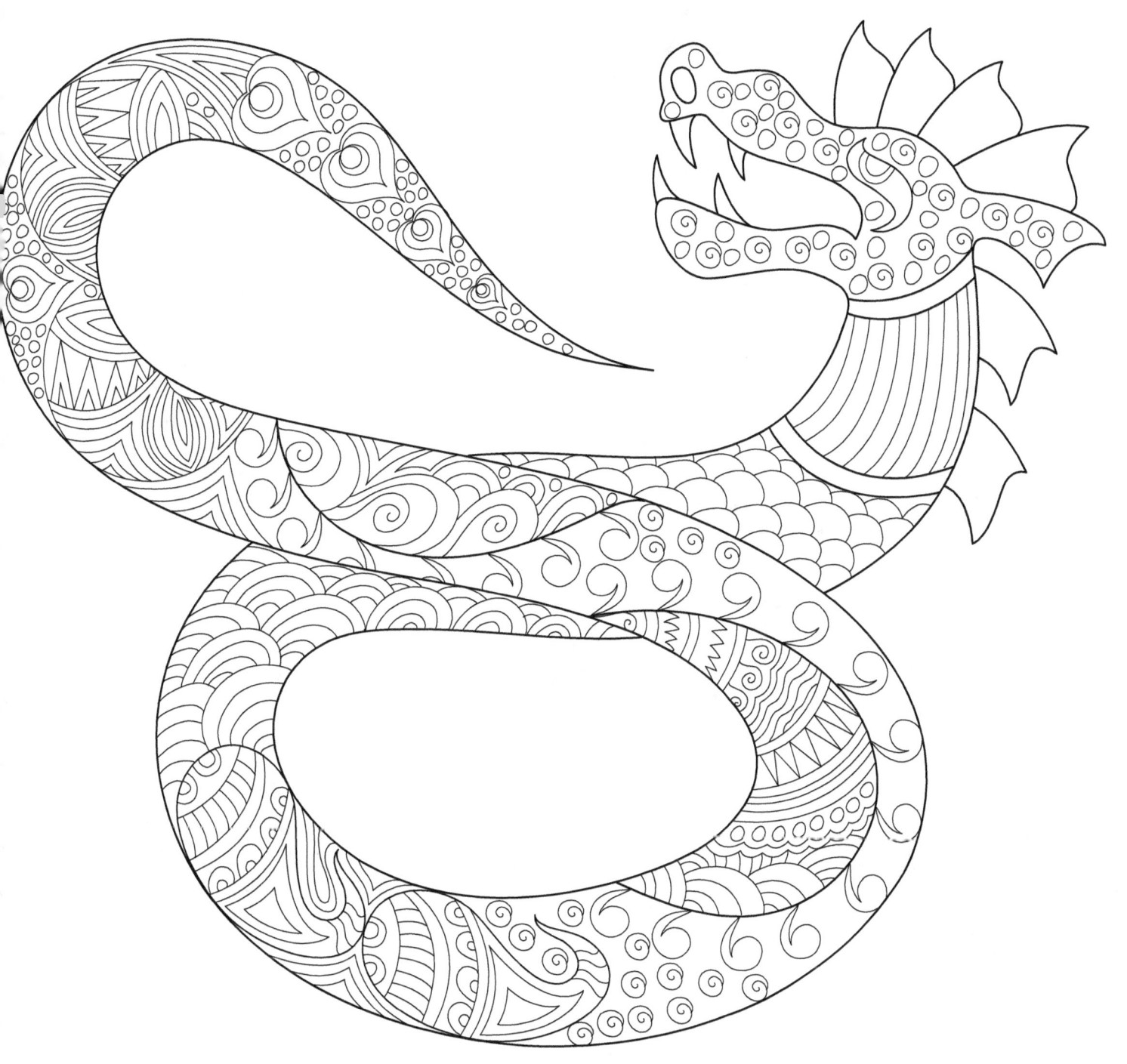

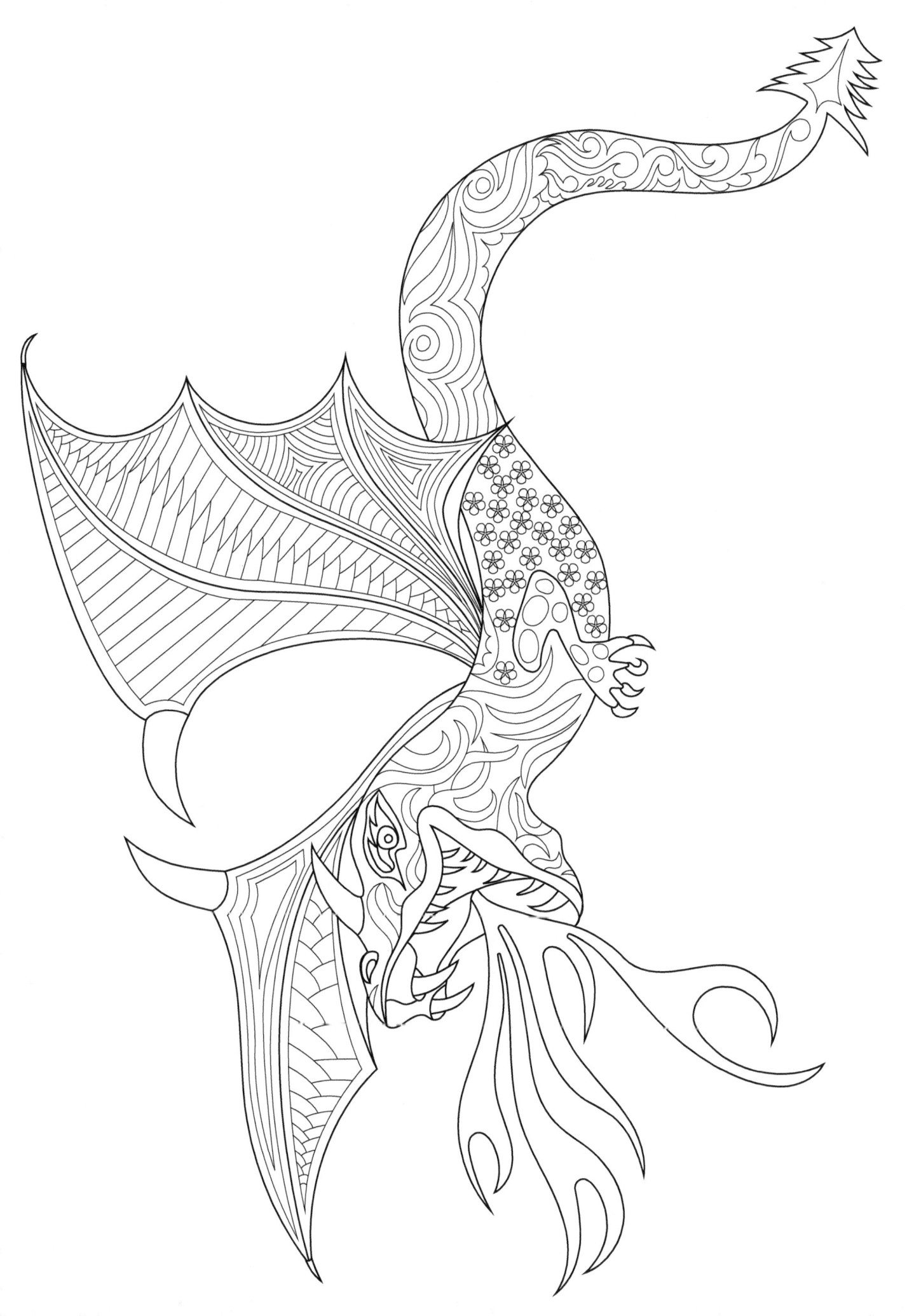

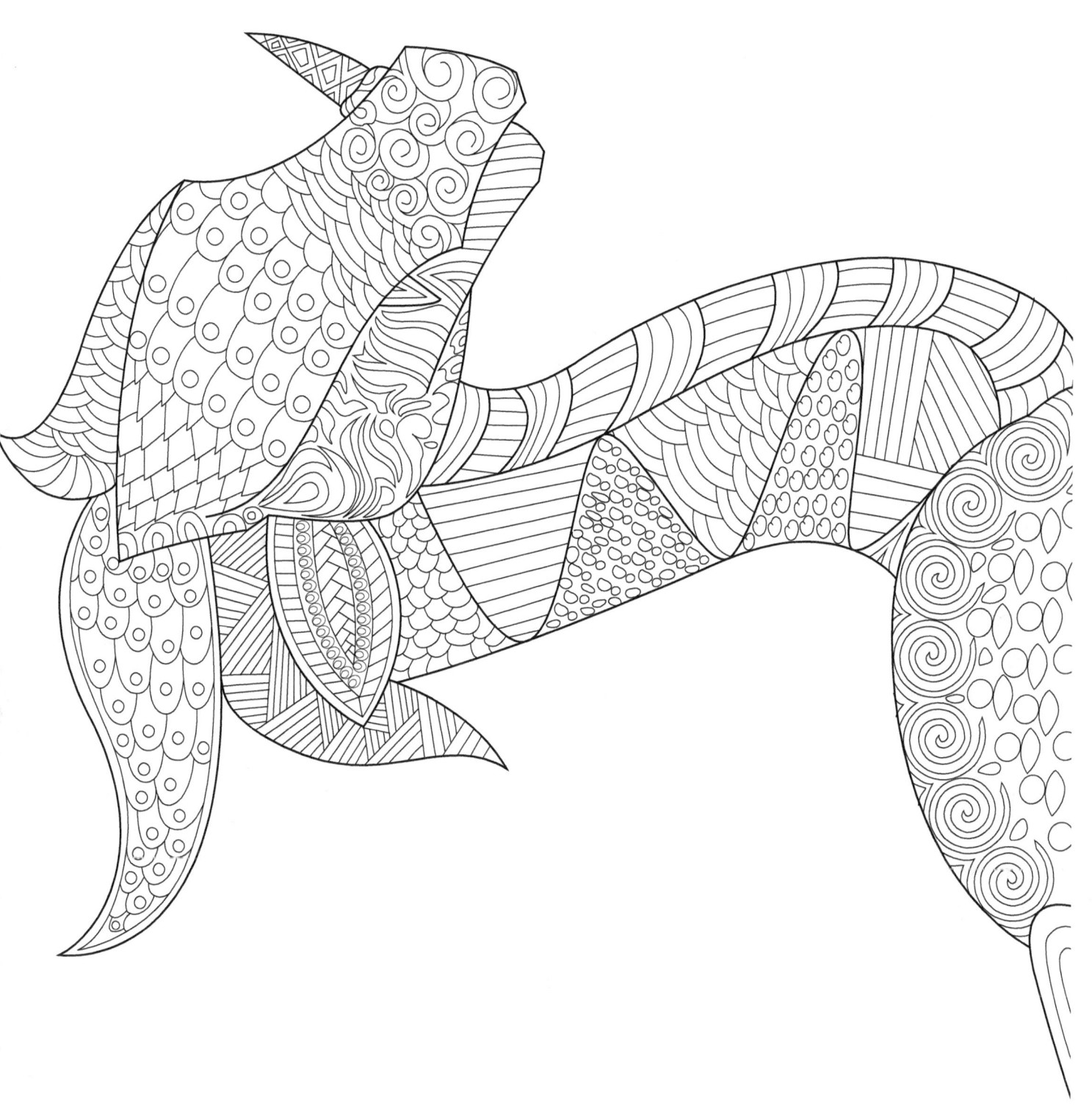

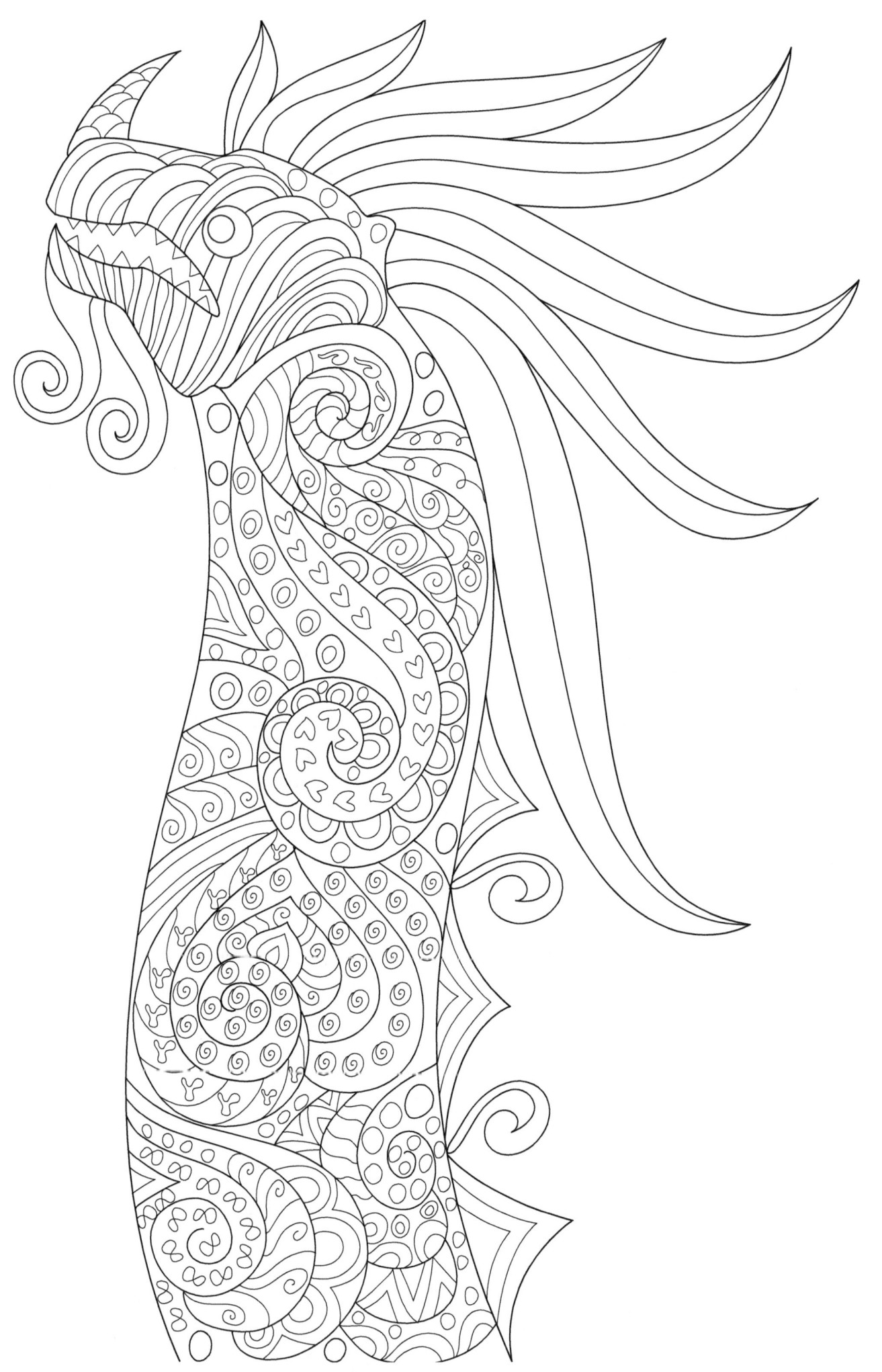

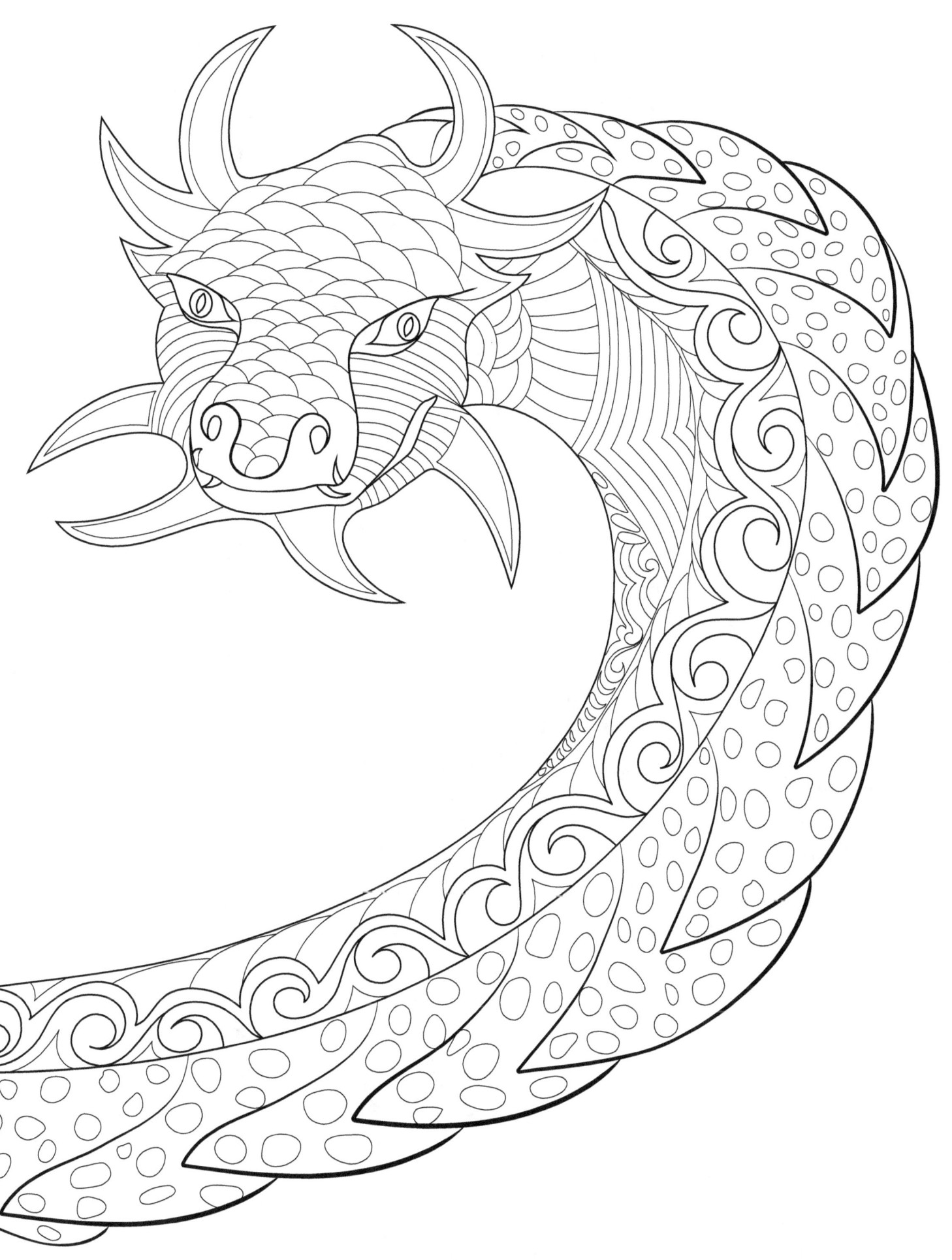

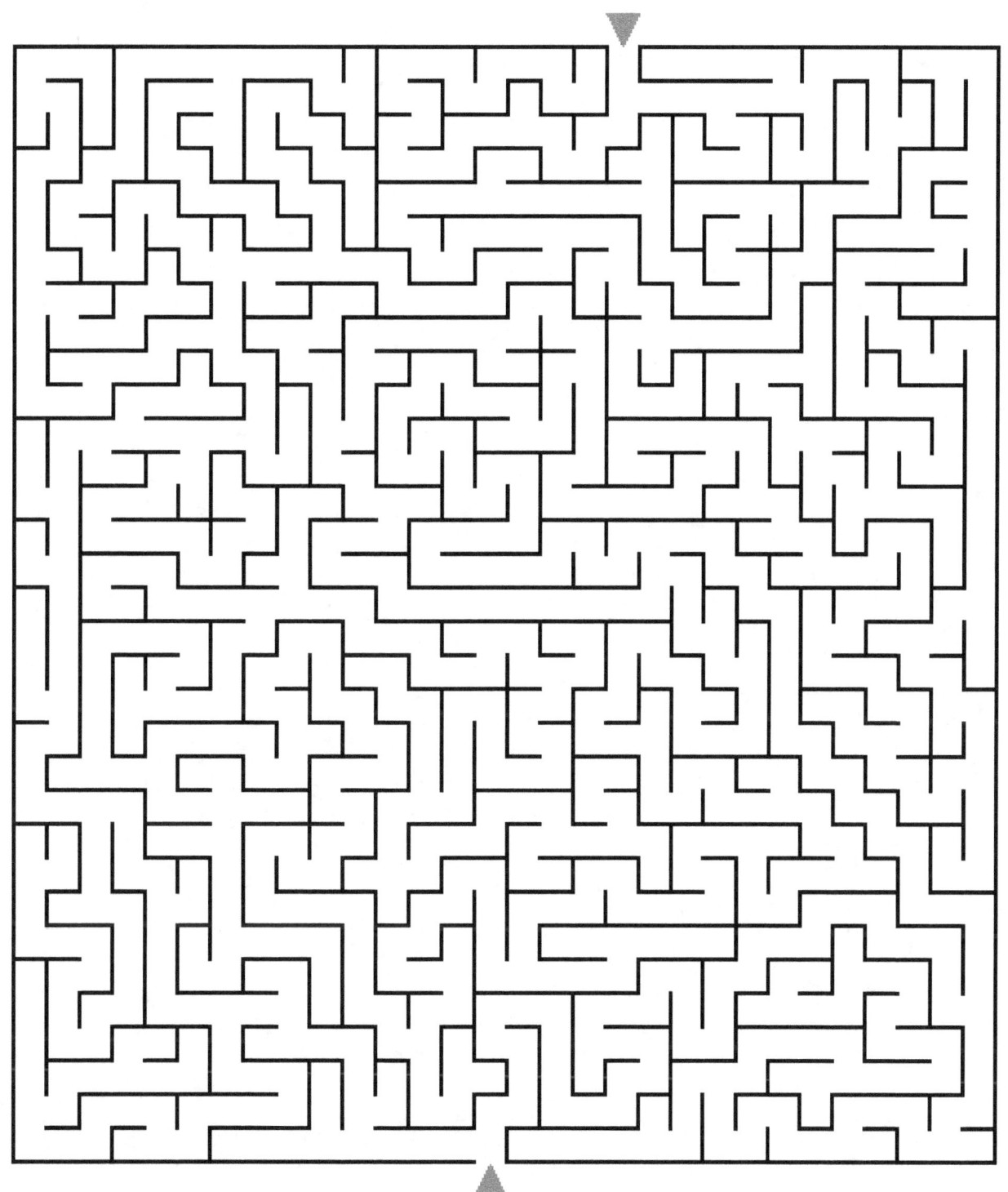

Solución

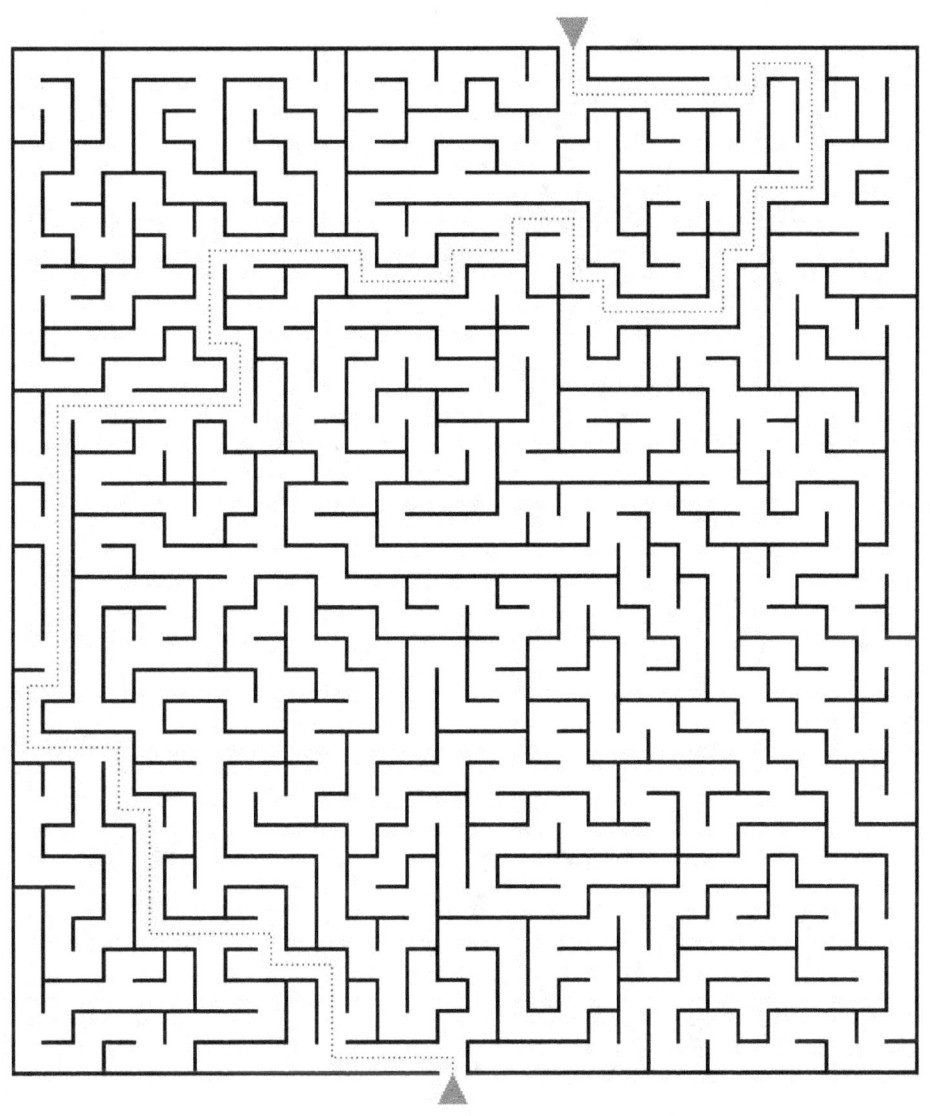

www.ingramcontent.com/pod-product-compliance
Lightning Source LLC
Chambersburg PA
CBHW081502220526
45466CB00008B/2749